Published on the occasion of the exhibition:

Rona Lee: That Oceanic Feeling
John Hansard Gallery
28 August – 13 October 2012

Rona Lee: That Oceanic Feeling is a John Hansard Gallery exhibition supported by Arts Council England Grants for the Arts and University of Wolverhampton.

Rona Lee: That Oceanic Feeling is published by:
John Hansard Gallery
University of Southampton, Southampton SO17 1BJ
tel: +44(0)23 8059 2158 | fax: +44(0)23 8059 4192
email: info@hansardgallery.org.uk | www.hansardgallery.org.uk

ISBN: 9780854329489
Design: Adrian Hunt Print: MWL, Wales
All images courtesy the artists unless otherwise stated.

Grateful thanks are due to all staff at John Hansard Gallery: Stephen Foster, Ros Carter, Julian Grater, Zoha Zokaei, Adrian Hunt, Ronda Gowland-Pryde, Val Drayton, Jack Lewis, Eloise Rose, Nicky Anderson, Liz Jones, Hannah Collins and Jo Willoughby. Sincere thanks also to Joel Papps and Abigail Croton.

John Hansard Gallery is part of the University of Southampton and supported using public funding by Arts Council England.

Artist's acknowledgements
The artist is especially grateful to Dr Tim Le Bas, from the Geology and Geophysics Research Group at the National Oceanography Centre, Southampton (NOCS), with whom she has worked closely throughout and to the Leverhulme Trust who funded their initial collaboration.

Thanks are also due to many other staff at NOCS and of the Royal Research Ship, James Cook, whose patience and warmth in welcoming an artist interloper into their midst's was remarkable. In particular this work could not have been realised without the input of Colin Day, Mike Douglas, Jez Evans, Philip Harwood, Sally Heath, Veerle Huvenne, Barry Marsh, Bramley Murton, Leighton Rolley, Henry Ruhl, Jane Stephenson, Andrew Staszkiewicz, Dave Turner. and the crew of ROV Isis.

I have also been very fortunate to work with photographer Andy Wilson, artists Tim Olden (sound) and Lucy Cash (video), actress Anna Cannings and programmer Alan Folmsbee, whose skill and imagination have made such an important contribution to several of the pieces exhibited here. Similarly the essays of Andrew Patrizio and Kathryn Yusoff have truly illuminated this endeavour. I am indebted also to Rina Ayra, Christine Battersby, Ryan Bishop, Emily Brady, Katie Lloyd Thomas and Alice Sharp for their contribution to the symposium that accompanies the exhibition.

The generous technical support assistance of Ian Robertson, Fred Gately, Rob Naylor and Metropolitan Works (London Metropolitan University) has been crucial in realising a number of works. I am especially grateful also to The Ladies Art Group and Russell Martin of Art Quest for their critical input, along with numerous friends, peers and colleagues whose feedback has steered my ideas along the way. Mention should also be made of Aless Cattaneo, who was then a student at Winchester School of Art, and assisted me directly with my work at NOCS.

The support of Arts Council England and Wolverhampton University has made it possible develop my initial research into a new body of work with wider inferences.

I would also like to sincerely thank everyone at the John Hansard Gallery for supporting my vision for this project, and for their expertise in bringing it to fruition. Finally and firstly, however, thanks must go to Frank Higgins, whose technical expertise, aesthetic judgment and wonderful emotional support has been there throughout.

CONTENTS

That which is far off, and exceeding
deep, who can find it out?
Ecclesiastes 7:24

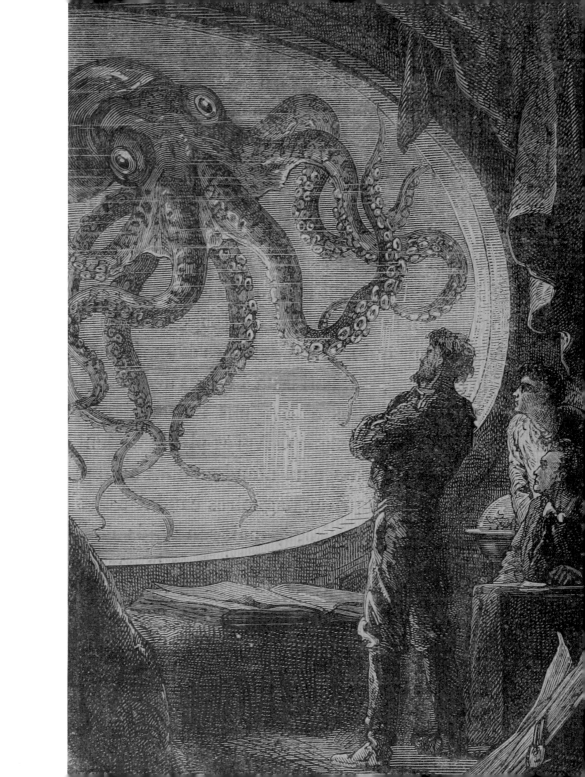

FOREWORD
Stephen Foster

It may seem obvious to claim Southampton's suitability for an exhibition entitled *That Oceanic Feeling*. A departure point for over a million cruise passengers a year and one of Britain's oldest ports, the city has a profound association with the sea. Yet, this is primarily a superficial – literally, shallow – relationship: after all, the passing of a 100,000 tonne ship goes unnoticed in the deep ocean.

The city's connections in fact run far deeper; The National Oceanography Centre, Southampton (NOCS) is one of the world's top five oceanographic research institutions. For an artist concerned with fluid, indeterminate environments, NOCS was a site of great opportunity and between 2008-10 Rona Lee was Leverhulme Trust artist-in-residence, researching undersea environments and human activity. This residency became the catalyst that would lead to *This Oceanic Feeling* at the John Hansard Gallery – an exhibition that investigates our relationship to the deep sea, asking what it might mean to 'look' into a space so embedded within the world's economic, political and cultural spheres, yet about which we know less than the moon.

For the John Hansard Gallery this project is the latest in a number of exhibitions focusing on the maritime as a site of enquiry, including *Stuart Brisley: Crossings*, 2008 and *Zineb Sedira: Seafaring*, 2009.

Fortunate as we are to have such a rich local context, the John Hansard Gallery building itself also has hidden depths: it was originally a University of Southampton laboratory, built in 1956 to house a giant tidal model of the Solent.

An exhibition and research project such as this involves the work, enthusiasm and expertise of many individuals, and we would like to thank everyone who has collaborated with and supported Rona over the past two years. We sincerely thank Andrew Patrizio and Kathryn Yousuf for their insightful publication essays – it has been a pleasure to work with them. We are grateful to Arts Council England through Grants for the Arts for supporting the development and realisation of Rona's work, and we also warmly thank the University of Wolverhampton for enabling Rona to undertake this ambitious project. Above all, our enormous thanks go to Rona herself, whose imagination, commitment and attention to detail throughout all stages of this exhibition have been fantastic. We are delighted to present such a compelling body of work that encourages us to think, hear, see and feel the most remote and inaccessible environment on the planet in new ways.

PROFESSOR STEPHEN FOSTER is Director of the John Hansard Gallery.

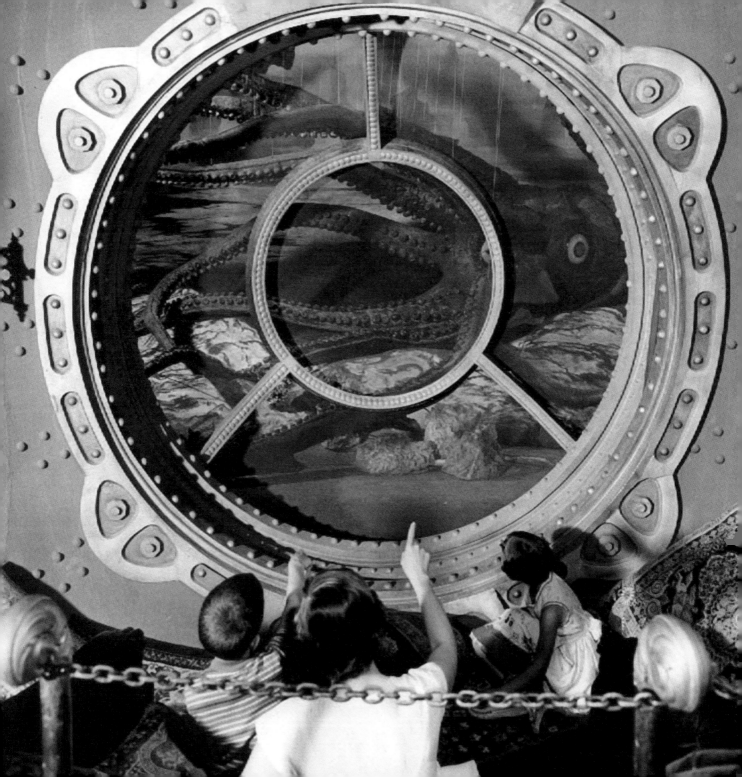

THAT OCEANIC FEELING
Rona Lee

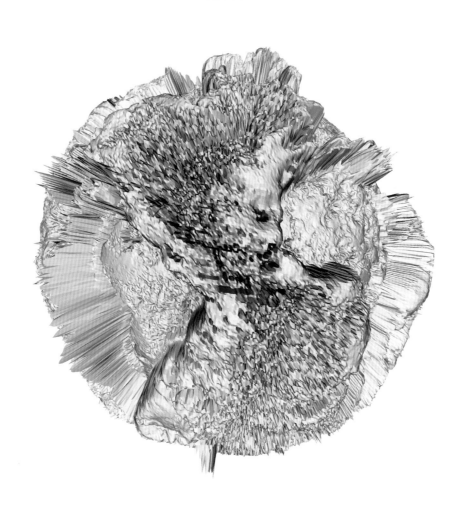

'I would just as soon have long arms: it seems to me that my hands would tell me more about what happens on the moon than you can find out with your eyes and your telescopes'[1]

The deep seabed constitutes the most remote and inaccessible environment on the planet, terra-nullius, terra incognita, a space 'outside' of geography, about which less is known than the moon. At the same time the contemporary sub-maritime represents a new economic, political and cultural frontier.

I grew up by the sea and much of my childhood was spent exploring the littoral landscapes of the Bristol Channel, a coastline that experiences tidal variances which are amongst the greatest in the world. The seeds of the investigation that has resulted in *That Oceanic Feeling* lie however to two more recent experiences. The first was the chance discovery of a bathymetric map of the globe which by reversing the normal cartographic conventions of representing land and sea offered a glimpse into a looking glass world, the earth appearing as an un-differentiated blank, the seabed as a world of unimagined contours and depths (taken up in *And all the seas were ink*). The second a dream (triggered by an experience I had while dive training in silt laden water of total physical

and visual disorientation) in which I leapt ecstatically off of a cliff into the depths below, the waking memory of which is echoed in *to dive, to fall, to float, to fly*.

Freud uses the term 'Oceanic Feeling' in both *The Future of an Illusion* and *Civilization and Its Discontents*, making reference to his correspondence with the writer Romain Rolland, who described it as "*a feeling of 'the eternal' […] without perceptible limits, and as if oceanic*"[2]. Unable to "*discover this "Oceanic" feeling in myself*", Freud suggests that it evidences an internalised remnant of the undifferentiated primitive ego as experienced by the infant prior to its separation from the maternal body.[3] It is perhaps the draw and simultaneous threat of such a sensation of what Kristeva, discussing the Oceanic, calls 'sensory plenitude' the desire for and anxious "*loss of self to what surrounds and contains us*" which lies at the heart of this work.[4]

So began a fascination with deep-sea - and in turn with the resistance it offers to methods of optical survey the combined effects of pressure and darkness necessitating that it be mapped acoustically - which was to result in *Truthing Gap*, a two year 'sci/art' research residency at The National Oceanography Centre, Southampton (NOCS) and subsequently developed here.

While at NOCS I documented aspects of oceano-graphic practice / life, learnt to use geo-scientific software, played with the conventions of bathy-metric representation and conducted various 'faux' experiments using facilities such as remotely operated underwater cameras. Technically the term 'truthing gap' refers to the need to verify remotely gathered data by direct sampling in this context it signaled a concern with the outwork-ings of differing systems of knowledge production. Contemporary geo-scientific visualisation drains the oceans dry, eradicating the play of the mo-tion and mutability to which the watery gives rise, shining the light of reason into its dark spaces in order to produce virtual landscapes, as scenic as they are scientific, over which the disembodied eye may roam unhindered. For Luce Irigaray - Braille readings from whose text *Marine Lover of Friedrich Nietzsche* are intercut in the video work Ama with undersea footage - the comparative difficulty of modern science in theorising fluids is echoed in the failure of western philosophical tradition to think through the fluid (and by extension to encompass the feminine).[5] Vestiges of aqua-phobia are evident too in Draining the Oceans 'a virtual scientific ex-pedition' commissioned by National Geographic, which 'pulls an imaginary plug' on the ocean,

rudely exposing the under-sea-scape to the skies and allowing geologists to stand unassisted on un-dersea features such as the mid Atlantic ridge.

If geophysics shows a predisposition towards the dry, visible and fixed, *That Oceanic Feeling* calls perhaps for a more liquid encounter with the deep sea, one which is capable of participating in Irigrary's libidinal positioning of it as the element of rapture.

Despite the seemingly scopic emphasis of much ocean science and its apparent alignment to what might be called an epistemology of distance, conversations at NOCS have revealed the extent to which sensuous understandings; emotional re-sponse and imaginative projection inform oceano-graphic study. One colleague told me of how the sight of small jelly fish, floating weightlessly along at a depth of 30,000 meters, had led him to reflect on the impact of gravity, as symbolised by the return to earth of death, in shaping our con-sciousness and how, had we evolved in an aquatic medium, buoyancy would have given rise to an unthinkably different metaphysics. Another of an instance when the temperature of a black smoker (undersea hydrothermal vent) was brought home to him not by the gauges on his instrument panel, but the experience of watching a length of ducting

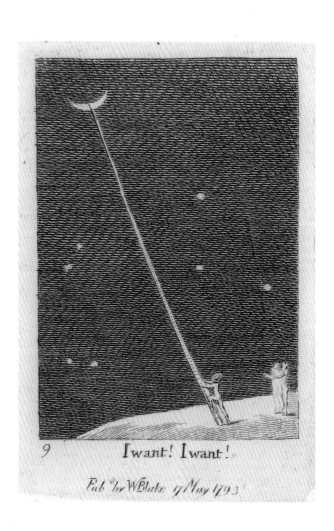

tape, attached to a piece of external equipment, melt away; activating an imagined sensation of the extreme heat involved.

In her history of oceanographic exploration Helen Rozwadowski comments on the way in which sailors originally used line soundings to conceptualise the shape of the sea bed, literally feeling their way across its surface in order to construct a mental map of the unseen terrain below.[6] The inescapable mutuality of touch, albeit imagined, has formed a constant preoccupation

in making this body of work. *I want I want I want,* involved the firing of handfuls of sediment - the residue of scientific samples collected from depths of about 4,000 meters below the surface so that the microfossils contained within them might be analysed. Once brought to the surface, a process which is recorded in the video piece *The Captain's Bird Table,* these 'mud cores' must be stored in atmospherically controlled environments in order to prevent them reverting to dust, a circumstance which might be read as a metaphor for the need to balance 'dry thinking' with liquid intelligence.

Named after an engraving by William Blake, which depicts a figure looking longingly up at the moon from the bottom of a spindly ladder, the impulsivity expressed in this tiny piece contrasts sharply with his later monotype of Isaac Newton, who sits at the bottom of the sea, gazing fixedly at a compass with which he attempts to draw a circle on the face of the depth, symbolising the singular vision of scientific materialism to which Blake was so opposed. Exhibited here alongside three photographs of my oceanographic colleagues, in which I asked them to imagine the very depths of the ocean, these petrified handfuls function perhaps in the manner of those stones favored by Chinese scholars for their capacity to promote contempla-

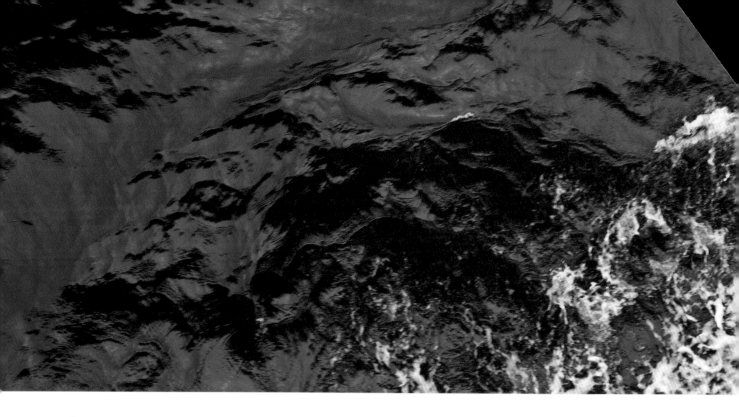

tive insight, invoking both a primal desire to hold the world in one's palm - suggested here by the fourth portrait in which my principle collaborator Dr Tim Le Bas looks towards the camera while squeezing two fistfuls of silt in his hands - and the ultimate futility of any attempt to do so.

Blindness is another re-current motif symbolising not simply the un-seeable character of the ocean below 1,000 metres, the Mesopelagic, Bathy Pelagic, Twilight and Midnight zones, into which light is unable to penetrate, but also sensory modalities which, like processes of sounding, are rooted in reciprocity. When I first watched underwater footage, shot by a remotely operated underwater vehicle (ROV), I became captivated by the mist like clouds of 'marine snow' (organic debris that drifts down to the seabed) which were thrown up when it touched the bottom. For my scientific colleagues these spiraling plumes, obscuring the underwater landscape as they do, were simply a source of frustration. Conversely the increased quality and volume of images captured at depth since I began working at NOCS has provoked a degree of ambivalence in me, echoing the inherent contradictions of artistically 'exploring' an environment to which I am drawn precisely because of its inaccessibility / invisibility, that runs counter to their sense of achievement.

Various commentators have remarked on the wider set of circumstances whereby culturally

the sea has been conceived in terms of nothing-
ness – nowhere, no thing, meaningless materiality,
even the romantic idea of the freedom of the seas
has its roots in Hugo Grotius' 1604 legal treatise
Mare Liberum, the purpose of which was to secure
unimpeded passage for trade over and across the
oceans. While contemporary imaging of the deep
sea has given it a new place in our consciousness,
mitigating perhaps against the polluting effects
of an 'out of sight out of mind' mentality, it has
simultaneously opened up fresh spaces of colonisa-
tion.

While making this work I have frequently
pondered the extent I have become a participant
in a process of bringing the world into represen-
tation which by its very nature runs counter to
the possibility of inter-subjective encounter. My
strategy has been in part to observe the observ-
ers and in so doing invite reflection on the limits
and possibilities of discovery, to playfully test the
ways in which knowledge is generated and finally
to produce objects which are perhaps capable of
expressing an 'Oceanic Feeling'; works that, to my
combined frustration and relief, ultimately embody
their own representational inadequacy.

RONA LEE is an artist and Reader in Fine Art & Practice at the
School of Art & Design, University of Wolverhampton.

1. D. Diderot, 'Letter on the Blind' (1749) abridged translation
 in M. J. Morgan, *Molyneux's Question: Vision, Touch and the
 Philosophy of Perception* (Cambridge: Cambridge University
 Press: 1977), p.35
2. H. Vermorel and M. Vermorel, eds., *Sigmund Freud et Rolland
 Romain. Correspondance 1923-1936* (Paris: Presses
 Universitaires de France 1993), p.304
3. S. Freud, *Civilization and its Discontents* (Penguin: London,
 2002), p.3
4. J. Kristeva, (Trans. Anne Marsella) *A Freudian Approach – The
 Pre-religious Need To Believe* (http://www.kristeva.fr/believe.
 html [accessed 21st July 2012])
5. A. Stone, *Luce Irigaray and the Philosophy of Sexual Difference*
 (Cambridge: Cambridge University Press, 2006), p.98
6. H. Rozwadowski, *Fathoming the Ocean: The Discovery and
 Exploration of the Deep Sea* (The Belknap Press of Harvard
 University Press: Cambridge, MA and London, 2005) pp 69-71

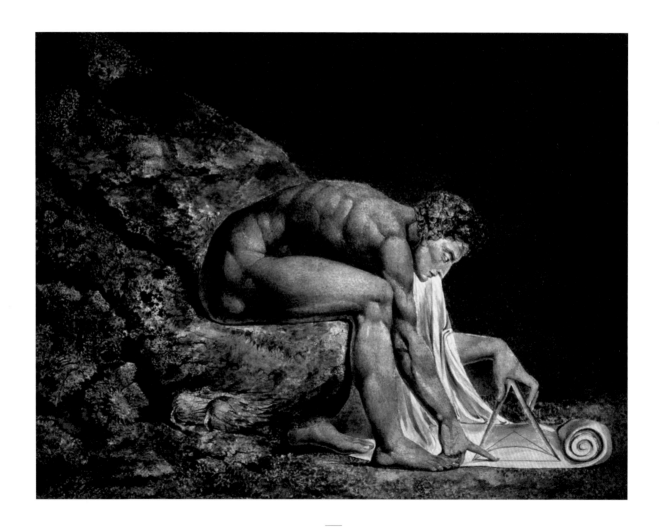

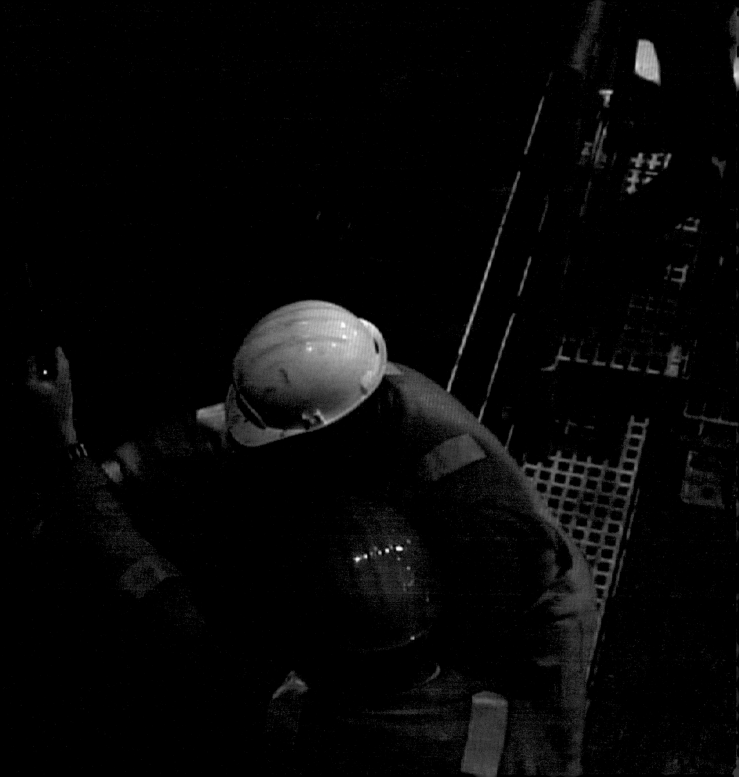

VOLUME WITHOUT CONTOUR:
FATHOMING THE ART OF RONA LEE
Andrew Patrizio

'New organs of perception come into being as a result of necessity. Therefore, increase your necessity so that you may increase your perception.'
Sufi poet, Jalaluddin Rumi (1207-73)

It is natural to take as a starting point for Rona Lee's exhibition the dialogue between art and science. Indeed we will look carefully at how Lee has constructed her particular extended engagement with oceanographic research in order to realise a remarkable series of works. Here, though, I simultaneously want to explore another idea that seems fruitful in understanding the value of her art, and so situate it in a slightly longer trajectory of recent art practice. Is Lee taking on the mantle of the ocean as a metaphor for the female body that can point us in new directions in gendered art, above and beyond, or perhaps through, the notion of an art/science encounter?

We will need to reflect on how the ocean operates in today's social 'imaginary'. Are we starting to think about the world's oceans differently, becoming emboldened in exploiting their movements and depths, their treasures - both the ones they offer up easily and those that have to be more forcibly extracted? The male-dominated value system represented by the human body in art was radically altered and expanded by women's performance and installation art (and indeed in more traditional media too) over the last 40 years or so. Lee seems to be reading the ocean through art in the same innovatory spirit as her female predecessors used the body in art a generation ago.

It is a commonplace that the oceans of the world are a set of spaces that have inspired deep awe in the cultural imagination of the peoples who have lived intimately with them. They show characteristics that are truly too various to capture, from the terrifying and dangerous to the inspiring and nurturing. The oceans of the world are economic, political and cultural spaces and indeed, over many of their parts, deeply unknowable spaces beyond the reach of the illuminating searchlight of Enlightenment science. Until the very recent present, oceans have stood at our feet as a reminder of the limits of human mapping and exploration.

Rather than think of the world's oceans as being a key object of Romantic philosophy, we can certainly say that they are a collective space of the Numinous (the presence of the supernatural or divine). The Pre-Socratic philosopher Empedocles is credited with coining the phrase: 'The nature of God is a circle of which the centre is

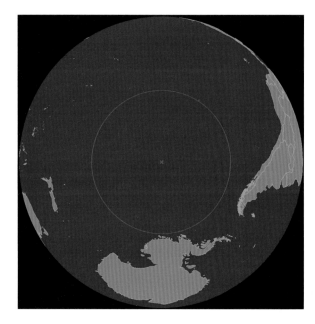

everywhere and the circumference is nowhere' – I think of this quote when I see one of the images that Lee has pulled into her research, which shows the Oceanic Pole of Inaccessibility. Since human culture emerged, our oceans have given rise to special states of mind that put our consciousness in touch with a reality that lies beyond all given systems of interpretation. They are 'tremendous'

in the true sense of that term, they overpower us, often literally, with their majesty and force, containing within them energies entirely beyond us. (Our recent attempt to tap their tidal force is only the most recent example of how we have sought to extract energy and economic power from this numinous, ever-present body.) Ocean and space exploration have shared the characteristic of offering specific (and often expensive) avenues of traditional knowledge harvesting (through visits to watery and spatial peripheries) whilst simultaneously offering much more striking moments when human consciousness feels entirely restructured, changed and inspired, in contact with a world largely beyond direct sensory experience – yet frighteningly, assuredly there.

But also here – the dualistic split between our inner lives and the oceans around us is becoming modified to a greater or lesser extent, as we realise the ecological impact our own activity is having on the planet. This is leading us to see that 'outside' and 'inside' are not stable categories and indeed may even be life-threatening errors of perception. One of the great nature writers of the last century, Rachel Carson (whose most famous work is *Silent Spring* written in 1962), wrote eleven years earlier in *The Sea Around Us* that:

The tragedy of the oceanic islands lies in the uniqueness, the irreplaceability of the species they have developed by the slow processes of the ages. In a reasonable world men would have treated these islands as precious possessions, a natural museum filled with beautiful and curious works of creation…[1]

In our unreasonable world, the oceans are swallowing up these islands as they become, inch-by-inch, new Atlantises.

This cyclical sense was captured by Matthew Arnold in his poem *Empedocles on Etna* (1852):

> *To the elements it came from*
> *Everything will return.*
> *Our bodies to earth,*
> *Our blood to water,*
> *Heat to fire,*
> *Breath to air.*

Empedocles, referred to above, is credited with the first comprehensive theory of light and vision. He proposed the idea that we see objects because light streams out of our eyes and touches them. This may run counter to modern physiology but his insight speaks of the materiality of seeing and that touch, whether it be of light beams or

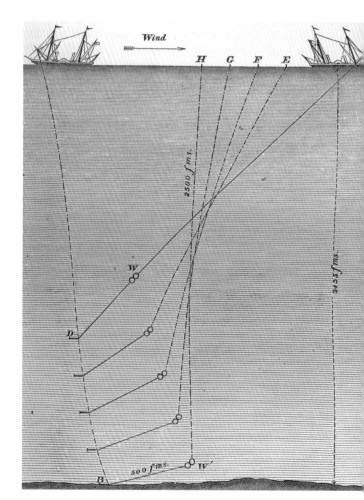

our own bodies, bears a direct relationship to the knowledge we thereby accrue.

Lee's work as a whole constantly uses this interplay between light and touch. A number of her large portraits of the oceanographic team in Southampton include researchers holding or playing with lumps of mud, with eyes closed as if meditating on the messy, weighted reality of underwater material. The portraits are set against a contrastingly unmessy backdrop of digitised data-rich renditions of the earth's oceans.

Old marine traditions blend alongside the new at many points in Lee's work. The use of connected lead weights dropped systematically from ocean-travelling ships by early oceanographers is echoed in the play of gravity and resistance in the plaster casts based on drawings Lee made by suspending a pen from the ceiling of the ship she travelled on. Like a line dropped to the ocean floor, the paper is marked blindly, generating abstract yet direct information about the haphazard rolling of the

ship. The title of this work, *Sea / Draw (10 Atlantic Days)*, itself plays on the relevant double meaning in English between 'sea' and 'see' and in drawing as both the graphic technique and the verb associated with pulling.

Homage is again paid to the dropping of weights to 'sound out' the ocean floor in a particularly complex and ambitious performance created by Lee at the National Oceanography Centre's waterside campus in Southampton, that has resulted in the video work *A sailor went to sea, sea, sea I*. Over six hours the artist walked up and down the side of the Empress Dock, a restricted area used to store heavy oceanographic plant, in view of the NOCS staff canteen and administrative offices. The 10,923 metres of string that she lay out was enough to reach the bottom of the deepest surveyed point on Earth – Challenger Deep.

The work is mainly constituted from dry material laid out in thin strips like a careful drawing on paper. The film though is intercut with footage

of wet and uncontrollably fibrous string, tossed to the water's eddies, saturated and heavy. For the gallery intervention entitled *A sailor went to sea, sea, sea II,* six miles of thread will be wrapped around a column within the exhibition space – evoking complex layers of association, from Ariadne's thread that led Theseus out of the Labyrinth to the encircled mooring posts of ports and harbours.

The primary juxtaposition is of an object (balls of string neatly laid out on the ground at the beginning of the performance) with a phenomenon, a field of entanglement with only faint echoes of its tidy relative. Despite its root in oceanographic science, there are clear links to other artists, such as Eva Hesse's *Hang Up* (1965-66), Richard Long's *A Line Made by Drawing* (1967) and Cornelia Parker's *Measuring Niagra with a Teaspoon* (1997). Lee shares with them all an interest in boundaries, liminal points and the limits of the quantifiable.

Seen from a slightly different perspective, feeling the bottom of the ocean is a process that bears comparison with how blind read braille. Both are learned translations from touch to graphic representations of the unseen. So when Lee works with blind actress Anna Cannings, the resulting work, *Ama,* offers up a connection that bridges two different practices, oceanographic mapping and braille reading, in order to say something about light, vision, touch and how these come together to remake knowledge.

The actual text that Cannings delivers, by Belgium eco-feminist philosopher Luce Irigaray (1932-), speaks of identity and merging with the other. One such section reads:

…the man who gets too close to the other risks merging with it. The man who stays too close to the other risks sinking into it. The man who penetrates the other risks foundering in it.[2]

This might signal a return to Empedocles, whose own legendary death was by hurling himself into Etna, on his home island of Sicily, in order to prove (fatally) a metaphysical point about existence. We

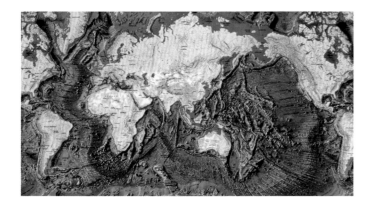

have since devised the term 'Empedocles Complex', as that strange pull many people feel when looking over vast depths or vertical falls, to hurl themselves, like Empedocles, into oblivion. This is not a suicidal urge it seems, but a primal curiosity about becoming one with the powerful forces of nature that pull us towards them.

I wish to turn now to another inspiration for Lee. The art of mapping can be seen as a first stage towards economic and political exploitation, a process that can speed on rapidly once unseen terrains have become demystified. Many maps are invariably things of aesthetic beauty and mesmerising detail, yet they are at the same time data-rich objects impelled by trade routes, colonialism, exploitation, cable laying, tourism, and energy extraction. Lee has since come across, and been fascinated by, American geographer/cartographer Marie Tharp (1920-2006), a significant map-maker of the twentieth century, who clearly excelled in her art and pioneered as a women in a male-dominated profession. She synthesized research data, produced diagrammatic line drawings of ocean floor profiles and worked with Austrian

landscape painter, Heinrich Berann (1915-1999) to depict the great underwater valleys and peaks, seamounts, scarps and canyons, all gloriously exposed.

This was the first comprehensive map of the ocean floor, laying the groundwork for proving the then-controversial theory of continental drift.

We might say that Tharp was reading the braille of the ocean, in being employed to interpret the soundings produced through sonar signals that measured the ocean's depths and turn them into graphic art. Such drawings are termed physiographic, in that they are renditions that make the mountains appear in three dimensions, as if seen from a low-flying aircraft. The public impact beyond the specialist realm has been high, as they take no real training to decipher and offer the kind of immediate knowledge that the 'Earthrise' photograph taken from the moon by the Apollo 8 astronauts in 1968 did, raising human consciousness of our floating planet similarly.

As we have seen above, Irigaray's theoretical reflections on identity are key post-structuralist reference points, among others, for Lee's practice as an artist and one of whose essays provides the

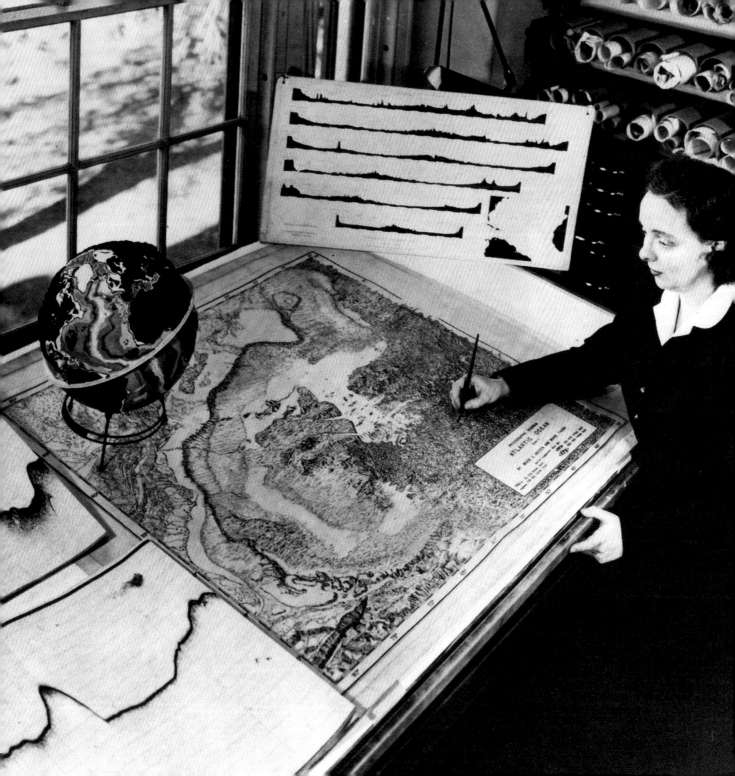

title of this text. Irigaray proposes a female sexual identity that is radically unique and autonomous from the dominant male position. She challenges a male discourse that defines woman as an Other, particularly in Freudian thought, to further define the male, thereby challenging such structural opposites so beloved of men, such as positive/negative, nature/culture, and the like. In one passage, Irigaray writes (as if she was speaking of male cartographers!):

Abandoning his flat surfaces, his clear contours, his unambiguously framed form, his calculations of proportions established once and for all, his immutably reflected unity…[3]

She goes on to celebrate volutes, helixes, diagonals, spirals, curls, turns, revolutions and pirouettes very much the forms and figures encouraged in Lee's own aesthetic.

It strikes me that Lee's work suggests possibilities of treating the ocean in similar ways to how traditionally trained artists once used the human model in art class. We have come to a point in oceanographic mapping that parallels a point reached some decades ago (and certainly since the completion of the Visible Human Project in the mid-1990s) where the entire material formation of the body is known, coded and recycled back into society as accepted knowledge. Women artists have been highly attuned to the predominately male discourses around anatomical and medical study – Lee herself records in a blog of 2009 that '*Somewhere in my mind I have the image of the seas peeled away from the earth like the flayed skin of anatomical ecorche.*' But they have also sought ways to indicate that bodies have smell, ordure, weight, pollutants and disease, volition and drives, attractions and conquests, rhythms, fluids and materiality, and hidden as well as visible parts. This list can be applied equally to the oceans of the earth and Lee's work is one powerful way to remind us of this and connect us to new truths of natural perception.

Lee has often created artworks through which we see the world differently. This is an aspiration or a quality that virtually all good artists have, though in Lee's case she plays with literal, enriched models of the world in order to effect that oblique perspective. Her reversed worlds in both two and three dimensions are the result of manipulating computer visualisations and three-dimensional printing technologies to create an uncanny, inverted world; not so much a 'world turned upside down' but one turned inside out. There is a playful politics behind this art, steeped in feminist alterity

and daring, a game changing strategy that uses the orthodoxies of scientific rendering to provoke us to change our perspective.

Irigaray has written of her disappointment when confronted with women's art that expresses anguish and horror. Thus she reflects: '*The experience of art, which I expected to offer a moment of happiness and repose, of compensation for the fragmentary nature of daily life, of unity and communication, or communion, would become yet another source of pain, a burden.*'[4] Lee's work is not comfortable or compensatory but it does set us against fragmentary lives and points us towards unity and communication.

ANDREW PATRIZIO is Professor of Scottish Visual Culture at Edinburgh College of Art in the University of Edinburgh.

1. R Carson, *The Sea Around Us*, 1951, Panther, London, 1965, p.119
2. L Irigaray, Marine Lover of Friedrich Nietzsche trans. Gillian C. Gill, Columbia University Press, New York, 1993, p.52
3. L Irigaray, 'Volume without Contours', in *The Irigaray Reader*, ed. Margaret Whitfield, Blackwell, Oxford, 1992, p.64
4. L Irigary, *Je, Tu, Nous. Towards a Culture of Difference*, translated by Alison Martin, Routledge, London, first English edition, 1990, p.107

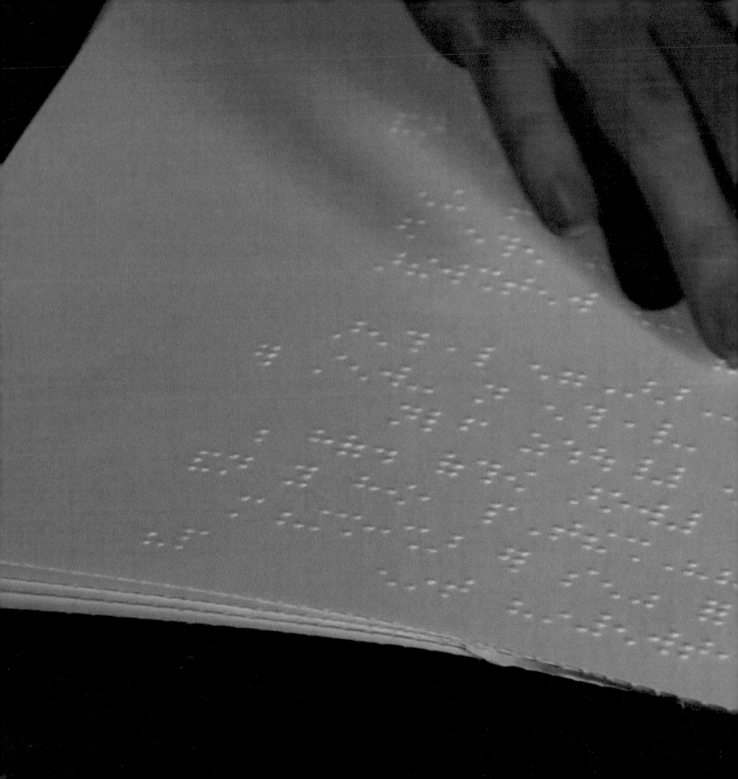

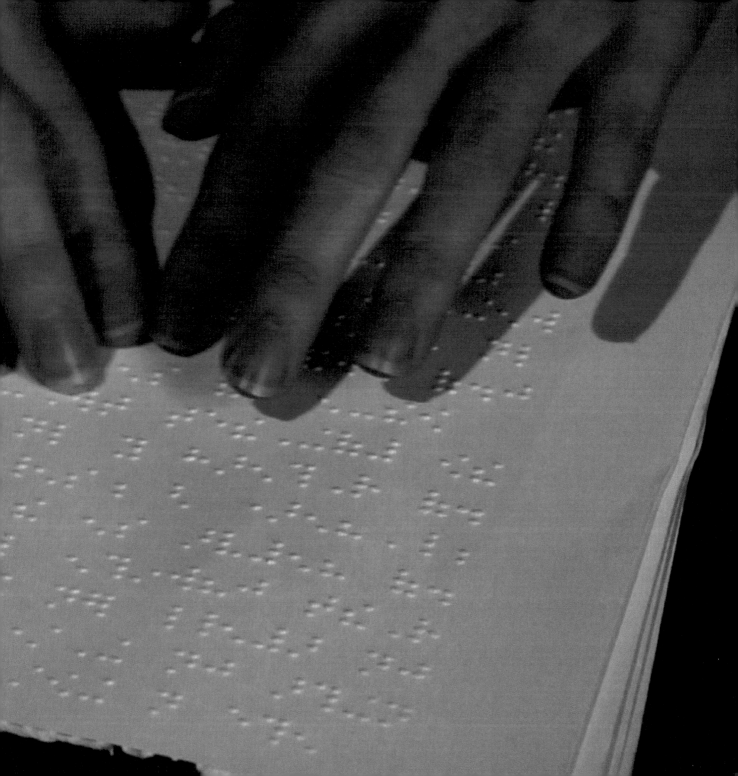

FATHOMING THE UNFATHOMABLE
Kathryn Yusoff

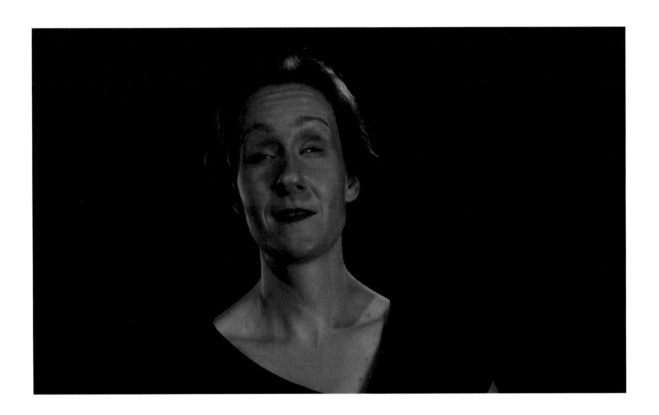

If we consider in the appearance of things only that which is intelligible to us, then we would be at best partially sighted. At worse, we would bring a frame of reference to bear on a material world that is a hindrance to the very possibilities of intelligibility of that difference. This was the case in the Antarctic at the turn of the 20th century, when explorers dredged up strange creatures from the seabed, which came blinkingly into the world of the sun (a world governed by heliotropically inspired notions of visibility), and marvelled at their axiomatic deviation from the norms of sight.[1] What these explorers found was that sea creatures had either developed gigantic eyes or lost them all together. These notions of gigantism and blindness were perceived as two sides of a seesaw about the pivot of the norm, of rational sight, and of the priorities of visibility. What these explorers failed to understand was what was most extraordinary about these benthic creatures and their ingenious adaptation to what we perceive as the darkness of the deep seas. By way of an introduction to the work of Rona Lee, the problematics of knowledge that haunted nineteenth-century geographic projects of terrestrial exploration have found a new terminus in the deep seas of the oceans, where Lee has been working for the past five years.

While Antarctica provided an awkward terminus to a trajectory of nineteenth-century geographical knowledge[2], it also raised a challenge in the context of terrestrial exploration to consider a more porous and shifting vision, which might have lessons to teach in other nonterrestrial worlds. Like visitors to the "Zone" discover in Tarkovsky's film, *Stalker* (1979), the usual practices of navigation are a hindrance in such an altered, mutable geography. If the nineteenth century was all about the horizontality of geographic projects, and the twentieth about verticality and the dominance of aerial space, we might contend that ours is a geographical age concern with depth. The major geographical projects of the day are concerned with "The Deep", with deep drilling, deep-sea bed exploration and bioprospecting the organisms of the deep oceans. It is in this deep of the sea that Lee's work is sited; as a site of the practices of science, imagination and difference. While science's trajectory is often concerned with incorporation and accumulation of the unknown into existing knowledge structures, it could be said that Lee is working to explore the disjuncture or gaps made by difference. Her work specifically poses the question of what it is to meet difference/indifference of these deep spaces, and to explore how this "other"

materiality and conceptuality diffracts through knowledge-forming practices, both visually and imaginatively.

This deep, like Antarctica before it, is an insensible, inhuman zone of the cultural imagination (our stories tend to take place upon the sea or at its shore, but rarely in its depths). Yet, it is these very depths that are increasingly being eyed for their biological, mineral and geopolitical worth (remember Putin's flag, theatrically planted on the Lomonosov Ridge to claim the seabed in the Arctic "gold rush"). It is oft remarked that the sea is less explored than the moon, but in some ways this is not surprising as the moon is a visible surface, in touch with the sun, and so it parallels our interest in all things that live by the work of that fiery ball

and is modes of illumination. The oceans, which are incidentally drawn by the moon, have a liquidity and viscosity that elude such easily resolved regimes of the visible (imagine what a photograph of the deep sea looks like). Like the clasped and fired grabs of deep sea mud in *I Want, I Want, I Want*, Lee's objects name an absence as well as a presence; they are what has been reached for, and what has eluded the grasp. As such, these "grasps" make perfect scholar's stones, for they are a site of contemplation on what can be recovered from research, and what always remains in abeyance. Like meteorites, which their chromed surface resembles, they speak of "other" places and unimaginable difference. The physical act of the grasp is presented alongside the imaginative act in

the Oceanographer's portraits, as we imagine their imaginations of what can be held from the deep sea.

Like so many attempts of science to make aspects of the sea objective (and thus appropriate for knowledge), Lee's work addresses this lacuna between desire and actuality, where there are slippages between that which is wanted for knowledge and that, which can be appropriated for it. A body of water becomes a body of knowledge in these actions, an ocean floor the context for the territorialisation of its resources. Lee's work operates at this intersection of the science of knowledge practices that are "representative" (simulations in computational mapping, soundings, oceanic sampling) and unease with this notion of representability, and its attempts to solidify and hold

still the overwhelming condition of the sea, which is its fluid mutability/mobility. And so, Lee gives us what liquidity leaves behind in *Sea / Draw (Ten Atlantic Days)* and *A sailor went to sea, sea, sea*, the liquid residues of motion are present as a different kind of empirical trace. The scribblings of the sea, formed by the rocking of the ship back and forth write another geography into a set of plaster reliefs. Lee's performance at the National Oceanography Centre, Southampton lays out 10,923 metres of string, enough to reach the bottom of the deepest surveyed point on Earth, Challenger Deep, on the dockside, over a six hour period, to materialise the length and time of depth's apex. Then the measurement of this point is "floated", becoming a strangely alien marker in the liquidity of the sea.

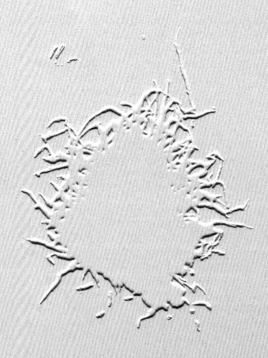

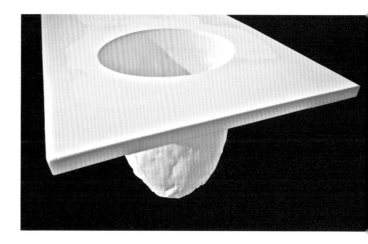

What happens, Lee seems to ask, when the tools of measurement meet the materiality under consideration? How do they intra-act to produce our understandings of these remote places enigmatically titled "Challenger Deep"? Volumes of absent space become monumental in Lee's work *to dive, to fall, to float, to fly* the iterations of depth and volume and substance become decontextualised as fluid stratigraphies of geologic signatures, at once alien, vertiginous and sonourous (in the case of *Mid Atlantic Sonata*).

We know the shape of the ocean through soundings, through sonar and scientific visualisations. But all of these "knowings" rely on the work of the proxy. It is a virtual ecology. We have a bathic imagination precisely because water is removed and the inverted geography of the sea floor is "uncovered" (much like the muscular geographies of the nineteenth century, uncovering women's bodies on the dissection slab or the rhetoric of Imperial exploration). There is the sensation of peeling away and oceanic rebound in *And all the seas were ink*. The sea itself, its liquid body, remains elusive. It is the thing we know least about in terms of research, and it is the vast responsive body that is changing most abruptly in the context of climate change with ocean acidification, thermal expansion and rising sea levels. Hooked onto this oceanic body are communities of islanders and those who live by and in the sea (both imaginatively, professionally and materially). What Lee's work does most successfully is problematise this proxy, redirecting and inverting its purpose. So, we are, for example, drawn to the tactile potential of these ocean stratigraphies, to the imaginative life of scientists, and to the inversion of space, of measurement and of depth. It is in this context that Lee works, and this matters precisely because it frames the mattering of the sea: its forms, visibilities, and modes of possession.

Lee alerts us to the fact that knowledge is always a form of appropriation. Knowing involves taking something, pursuing something – an idea, material, concepts—for knowledge, and thus, it is

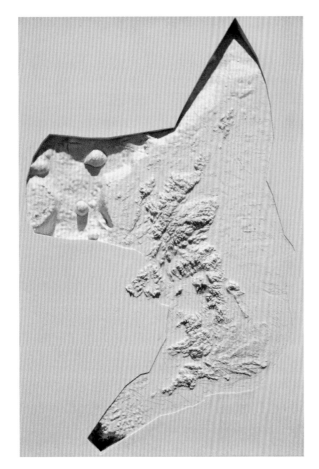

to uncounted and uncountable organisms, from the extraordinary to the monstrous.[3] Despite 250 years of taxonomic classification, ninety-one percent of life in the oceans was unaccounted for at the last survey count[4], which demonstrates the overwhelming excess of "insensible subjects" of the oceans that await description, nomination or apprehension by science. This other world suggests a different, even oceanic, ontology that challenges our default terrestrial practices. And, every attempt to bring "it" closer, to understand its "nature" is also a form of distancing, a form of recruitment into the world of the visible: this is the exchange from what is foreseeable to what is seeable.

And it is an exchange that is configured around the anticipation of knowledge-based gifts, whether they are biological, mineral, commercial or imaginative. What is exacting, and yet so affective about the video work *Ama* is how it makes manifest this exchange with the insensible, as the performance thoughtfully reworks the im/possibilities of the visible through the "blind" reading of the Marine Lover interspersed with footage of the sea. In place of the eyes as a proxy to this other world, there is a geography of touch and the temporality of a voice, subverting expectations about what will in fact, 'truth the gap.' Like Lee's earlier work, *The*

both a site of violence and desire. It involves chasing… an idea, data, objects, and a thousand quotidian practices and things that are enrolled in the making of a scientific paper or an art object. The desire is all too apparent in the dreams of science (and of art) to inhabit the uninhabitable, to extend out into that which is unthought-of. The sea is not our home, but it is home to the origins of life, it is the watery cradle of sentient bodies, and still home

Encircling of a Shadow (2001) at Newlyn Art Gallery, Cornwall, where she had a band of retired telegraphers signal a list of women's names, each that of a local fishing boat, out to sea with lights, accompanied by the singing of a male voice choir, there are echo's of the call and return that we associated with the sea, which is memorialised in the cultural figure of the siren.

The text, whether flashed out to the sea in Morse by the signallers, touched in Braille, or read across the topography of a 3D "printing" of the ocean bed, brings a very different mutable quality to what knowledge is. As Jacques Derrida comments:

One must always remember that the word, the vocable, is heard and understood, the sonorous phenomenon remaining invisible as such. Taking up time rather than space in us, it is addressed not only from the blind to the blind, like a code for the nonseeing, but speaks to us, in truth, all the time of the blindness that constitutes it. Language is spoken, it speaks to itself, which is to say, from/of blindness. It always speaks to us from/of the blindness that constitutes it.[5]

As such, Lee brings this speaking from/of blindness together in her piece, *Ama*, as Anna Cannings speaks Luce Irigaray's words, touching them, to speak from/of blindness to the Other; the Other

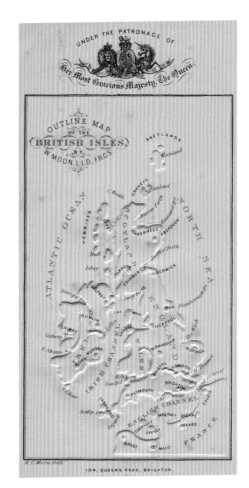

that is Irigaray's account of sexual difference, Nietzsche's blindness to woman, and the sea itself. The work is touching precisely because it touches on a point of truth in Irigaray's feminist text Marine Lover of Friedrich Nietzsche, and because it touches a wider truth about the im/possibilities of realising the world of the Other (the work reminds us of the constant "failure to recapture" a presence "outside of the abyss into which it is sinking,"[6]). Anna's blind eyes, once glimpsed, subvert the helioform of the eye, which Plato commented; of all the sense organs most resembled the sun (and its corresponding claims to knowledge and the centre of intelligibility that are underpinned by the hypothesis of sight). It is only later that we see the hand tracing the text; reading with the hands, foreseeing the unseeable, the im/possibility of a voyage. As Vicki Kirby reminds us, '*it is important to remember that the tactile is itself a language of differentiation and discrimination, as we see in Braille.*'[7] At the same time we also see the mobile, kinaesthetic and temporal qualities of drawing the sea into a readable text, its body into language. The reader remains unseen/unseeable, and yet, at the same time, claims a secret power in defiance of the prism (prison?) of the visible, which is diffracted through the sea.

While many art/science collaborations and commentary presume certain shared interests around the visual and orders of representation (particularly in the rendering of data), Lee's work has moved into a different register that resists this easy configuration predicated on the lure of the visible. She dislodges this neat axis of the visible that is used to establish a continuum of art and science interests, so that other modalities of knowing are realised for consideration that are internal to both art and science, but with often quite radically different directionalities and concerns. *In Untitled I–IV* the scientists/oceanographers, who are Lee's collaborators, are photographed with their eyes closed. The one that looks tightly grasps two handfuls of mud material remainders of the elusive depths. They are all looking elsewhere, seeing what is internal to the imagination: that which pulls images, knowledges, and their failures (the unseeable) into being. The will to know [savoir] and the will to see [voir] are for a moment turned inward in this work. What is caught is the movement of this exchange: the imagination, absconding into another dimension of materiality – the sea – free for a while from the pull of the grid of knowledge and its demands, free to fathom the unfathomable. It is a meditation on the more excessive concepts and materialities of a place – the oceanic – that many

of us will only know through a familiarity with its hard edges, be they shores, seafloors, harbours or territorial boundaries. Lee's work, in subtle and materially affecting ways, takes the axiomatic point of ocean knowledge production, visually and conceptually, and shifts it slightly. It is a tilt that speaks to the violence and love of knowledge of other places, its calls and returns, in both the scientific and cultural imagination, and it bids us to reflect on what we think we find there.

DR KATHRYN YUSOFF is Lecturer in Nonhuman Geography at the Lancaster Environment Centre, Lancaster University

1. A. E. Shipley 'Abysmal fauna of the Antarctic Region', *Antarctic Manual* (London: Royal Geographical Society, London, 1901).

2. The oceans may well be the "last place" in the terrestrial bias of the imagination, but as every last place before it attests to, the last is only ever a prelude to a conquering tautology that, like late capitalism, is a site of constant renewal for a new commodity frontier (for bioprospecting of marine organisms, petroleum and gas extraction, and seabed dredging). The history of the geology teaches us that if we wait long enough the sea will come to us to wash away our architectural signatures and material wastes. But this imaginary too, is complicated by what the sea has to hold in terms of wastes: atmospheric, nuclear, plastic, chemical. It could be said that the giant flushing system has just backed up.

3. The sea is populated with a geography of monsters that are figurations of all that threatens to engorge (giant squids), over whelm (Moby Dick), and to eat us whole (Jaws).

4. C. Mora, D. Tittensor, S. Adl, A. Simpson, B. Worm 'How Many Species Are There on Earth and in the Ocean?' PLoS Biol 2011 9(8).

5. J. Derrida *Memoirs of the Blind: The Self-Portrait and Other Ruins*, (Chicago: Chicago University Press, 1993), p. 4

6. Derrida, 68.

7. V. Kirby *Quantum Anthropologies* (Duke: Durham, 2011), p. 133.

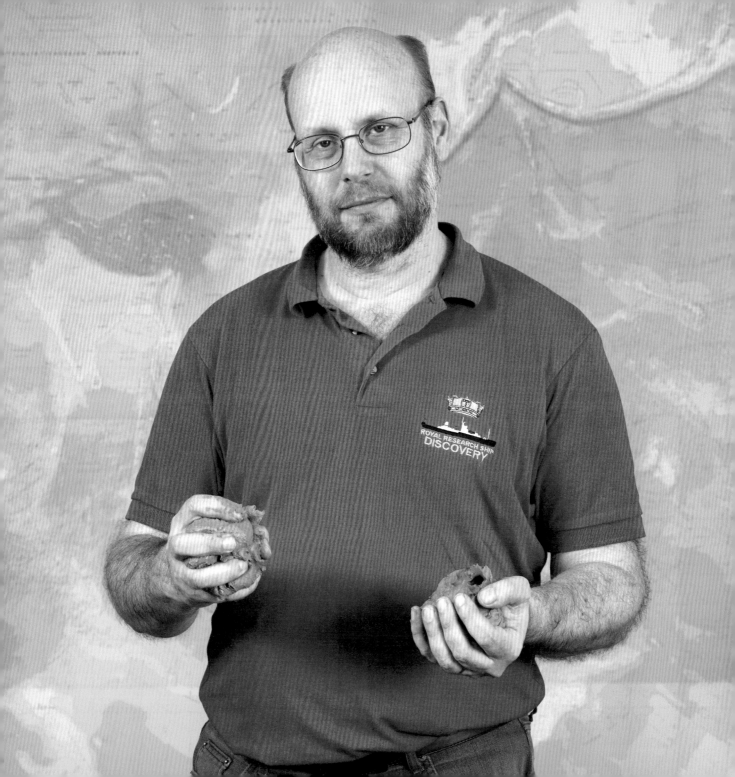

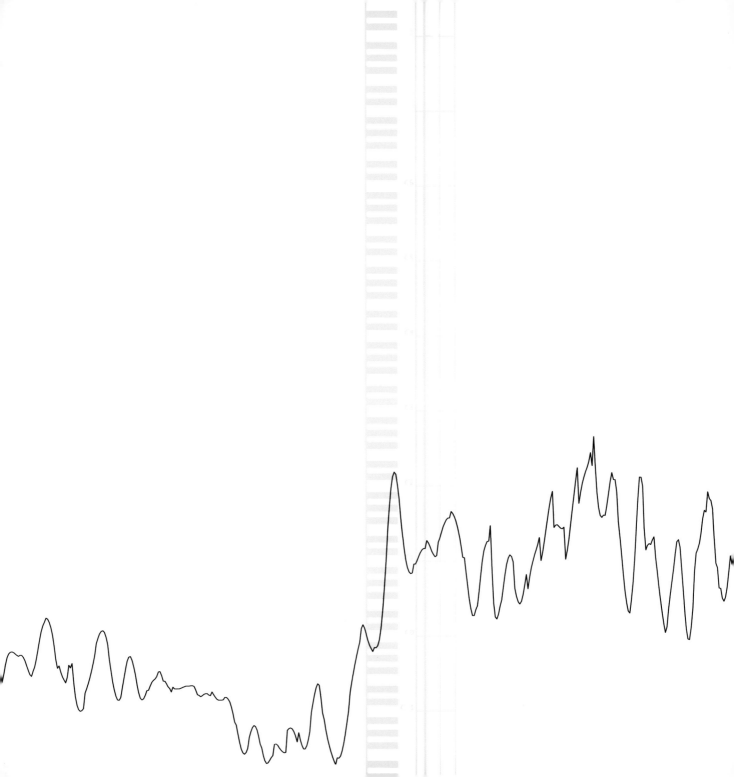

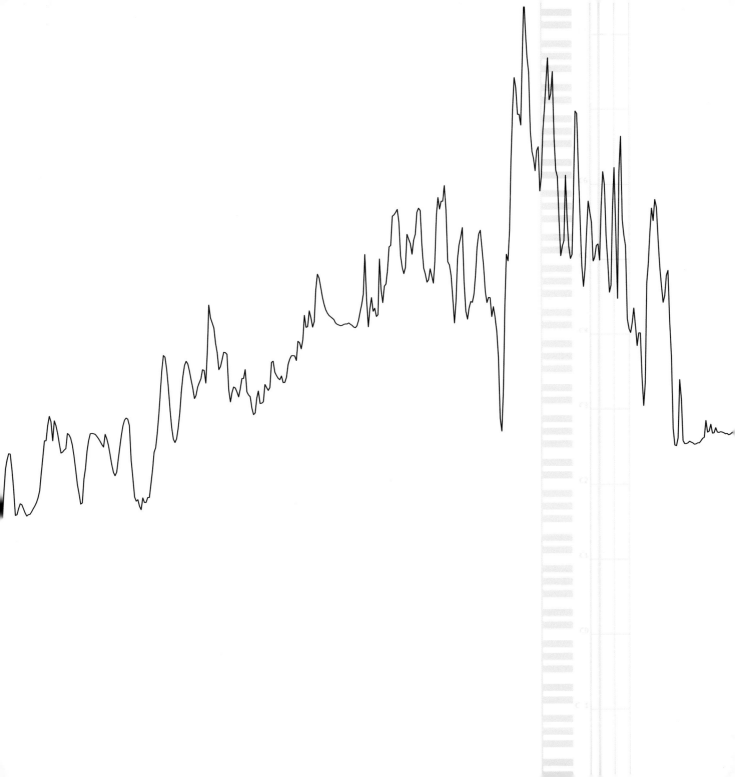

LIST OF WORKS

Ama, 2012
Single Screen Projected video. Duration: 7mins 30 secs
Original underwater footage by kind permission of Dr Bramley
Murton, National Oceanography Centre.
Extracts from: *Amant Marine: De Friedrich Nietzsche* by
Luce Irigaray. Copyright © 1980 by Les Editions de Minuit. Used by
permission of Georges Borchardt Inc.for Les Editions de Minuit.

Performer: Anna Cannings
Camerawork: Lucy Cash
Sound: Tim Olden
Editing: Rona Lee and Lucy Cash

Illustrated:
p. 10/11, 40/41, 42, 44/45,
56/57 (video stills)

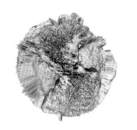

And all the seas were ink, 2012
Chromed Polyamide Laser Built Globe
Diameter 280 mm
Land / sea inverted (x 300) relief globe

Illustrated:
p. 14 (CAD model)

The Captain's Bird Table, 2012
Single screen projected video
Duration: 10 mins 17secs

Camerawork: Rona Lee
Editing: Rona Lee and Lucy Cash
Filmed on board Royal Research
Ship *James Cook*

Illustrated:
p. 8/9, 22/23, 24/25, 38/39
(video stills)

to dive, to fall, to float, to fly, 2010
Plaster / porcelain
700 mm × 410 mm × 20 mm

Illustrated:
p. 47

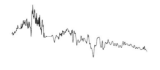

Mid Atlantic Sonata, 2012
Wall Drawing and Vinyl Record
Duration: 22 min 40 secs
Score generated from geo-physical profile of underwater
Mid Atlantic Ridge, the largest mountain range on Earth.
Note value taken from x position, Time from y position.
Sound Designer / Composer: Tim Olden

Illustrated:
p. 54/55
(score and source material)

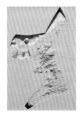

A new set of borders for the kingdom, 2010
3D z Corp mono print
Plaster / resin
210 × 297 × 30 mm

Illustrated:
p. 48

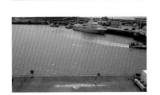

A sailor went to sea, sea, sea I, 2010/12
Single Screen Video Duration: 8 mins
Edited documentation of action involving 10.994 km / 6.831 miles
of string, enough to reach the bottom of the deepest place on
Earth, the sub-maritime Challenger Deep

Sound: Tim Olden
Camerawork: Rona Lee / Barry Marsh

Illustrated:
p. 37 (video still)
p. 36 (stills photography)

A sailor went to sea, sea, sea II, 2012
10.994 km / 6.831 miles wound black thread

Sea / Draw (Ten Atlantic Days), 2009
Wall mounted 10 x Herculite LX Plaster
210mm × 297mm × 16 mm
Cast reliefs of seaborne 'drawings' made
on the Royal Research Ship James Cook

Illustrated:
p. 30/31 (drawings)
p. 46 (relief)

11"21' North, 142" 12' East – Marianas Trench Abstraction, 2009
Pigment coated laser built model and glass dome
255 mm × 140 mm × 13mm

Computer generated model allowing an impossible viewpoint in,
around and through, the deepest place on earth, Challenger Deep.

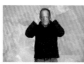

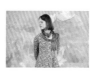

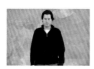

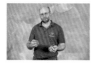

Untitled I–4, 2012
Drs. Huvenne, Murton, Ruhl and Le Bas
4 x C-type lambda print
48 × 72 inches. Surface mounted aluminium
Photographer Andy Wilson

Illustrated:
p. 34 (*Untitled I – Dr Huvenne*)
p. 52 (*Untitled 4 – Dr Le Bas*)
Photographer: Andrew Wilson

I want, I want, I want, 2012
Eight fired handfuls of silt collected at 4,000
metres below the surface of the sea
Chrome plated

Illustrated:
p. 26

LIST OF ILLUSTRATIONS

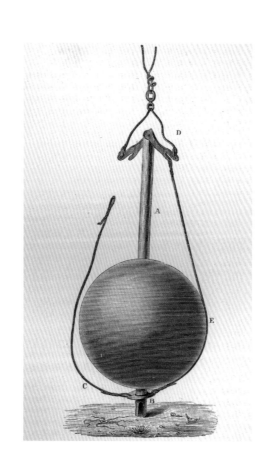

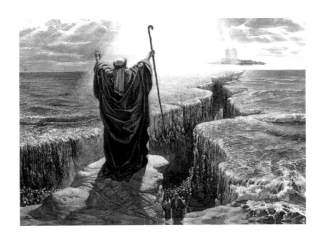

Then I saw "a new heaven and a new earth," for the first heaven and the first earth had passed away, and there was no longer any sea.

Revelation 21:1